BE OF
Good Cheer
A *Christmas* DEVOTIONAL

SUSAN HILL

ZONDERVAN

Be of Good Cheer

© 2024 Zondervan

ISBN 978-0-310-46319-1 (HC)
ISBN 978-0-310-46316-0 (audio)
ISBN 978-0-310-46320-7 (eBook)

Scripture quotations are from the Holy Bible, New International Version®, NIV®. Copyright © 1973, 1978, 1984, 2011 by Biblica, Inc.® Used by permission of Zondervan. All rights reserved worldwide. www.zondervan.com. The "NIV" and "New International Version" are trademarks registered in the United States Patent and Trademark Office by Biblica, Inc.®

Text written by Susan Hill

Photography by Noelle Glaze

Art direction by Tiffany Forrester

Illustrations by Muse Art and Beigetime / Creative Market

Interior design by Kristy Edwards

Printed in Malaysia

23 24 25 26 27 OFF 10 9 8 7 6 5 4 3 2 1

Contents

Introduction

I t's with good reason that the Christmas season is known as the most wonderful time of the year. There's no other time on the calendar when so much fun is packed into a few weeks. But all the extra events, parties, and celebrating might cramp your already busy schedule and leave you feeling more stressed than cheerful. Without meaning to, it's possible to go through the motions on autopilot and, on the night of December 25th, feel like you've missed the true meaning of Christmas. The good news is that with a bit of intentionality, you can get everything done, attend all the fun events, and still savor the true meaning of Christmas.

Be of Good Cheer invites you to slow down, take a few minutes each day, and focus on *who* and *what* you are celebrating. You'll ponder the simple things around you that make the season special. Most importantly, you'll pause and reflect on the birth of Christ and why your life is different because He was born.

With these things in mind, your Christmas season will be filled with traditions that make it magical—and a Savior who makes it meaningful.

Share your

happiness.

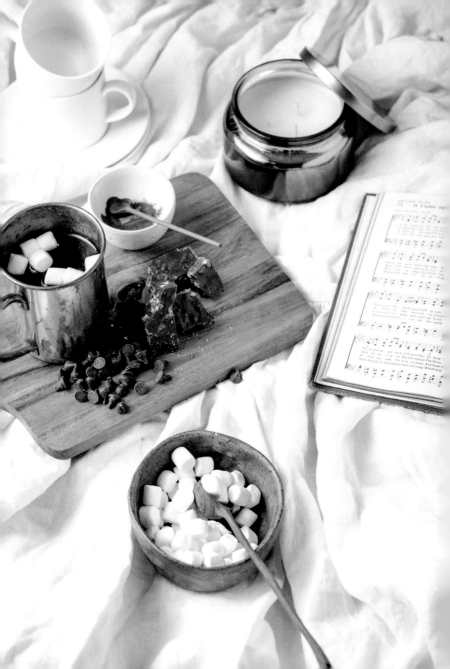

Cheer

Rejoice in the Lord always.
I will say it again: Rejoice!

PHILIPPIANS 4:4

D o you know a holiday Scrooge? You know the type: some-
one who scowls at the sight of decorations or mocks
a celebration with a worn-out "Bah, humbug!" But if you've
opened this book, there's a good chance you believe that the
Christmas season is a time to be of good cheer!

Jesus gives us all the reason we'll ever need to be of good
cheer. As the apostle Paul said, "Rejoice in the Lord always. I
will say it again: Rejoice!" But here's the thing: being of good
cheer is a lot more fun when you share your happiness with
others. Your most memorable holiday encounters will revolve
around friends and loved ones. Want to ramp up the cheer this
holiday season? Here are a few ideas to get you started.

- Make a playlist of your favorite Christmas songs and sing along as you go about your day.
- Bake something delicious and share it with your neighbors or coworkers.
- Try a new recipe—maybe a twist on a classic or perhaps a dish from a region of the world you want to travel to.
- Decorate a second tree this year. Pick a theme and go with it.
- Be a Secret Santa and deliver gifts anonymously.
- Volunteer at a local women's shelter, retirement community, or soup kitchen.
- Adopt a family in need and provide a meal and gifts.

You can imagine numerous ways to spread holiday cheer, and there's no right or wrong way to do it. The point is to amplify everything that is right in the world and do things that bring happiness to others. Even the smallest of gestures can start a ripple of joy. No promises, but maybe, just maybe, you'll convert a Scrooge or two.

Lord, thank You for giving me a reason to be of good cheer. Help me spread happiness to people who need to receive it. I pray You will give me unique ideas and opportunities and the ability to carry them out.

TWO

Gratitude

Let the message of Christ dwell among
you richly as you teach and admonish one
another with all wisdom through psalms,
hymns, and songs from the Spirit, singing
to God with gratitude in your hearts.

COLOSSIANS 3:16

Thanksgiving Day signals the beginning of the holiday season that lasts through the end of the year. Parades, turkey dinners, and pumpkin pie highlight the day as families and loved ones gather to celebrate all the reasons there are to be grateful. It's a time to acknowledge blessings big and small. What would it look like to carry that spirit of gratitude with you throughout the whole year?

Gratitude requires a shift in thinking that redirects your thoughts to the good things happening in your life and takes the

time to thank God for them. Most of all, it's developing an eye that spots blessings as you go about your day. Sometimes blessings are obvious: good news from the doctor, a job promotion, or an approved mortgage. Other times, blessings are subtle: a book you enjoyed reading, a warm home on a cold December night, or a good conversation with a friend. Practicing gratitude means pausing to acknowledge these blessings and giving thanks to God for them.

During this holiday season, consider starting a gratitude list, in either a journal or a notes app, where you can keep a short list of three to five reasons you are grateful at the end of each day. Doing so will train your eyes to look for blessings because you'll want new things to add to your list, so even when life gets hard throughout the next year, you'll be practiced in looking for and appreciating all the goodness.

Lord, there are countless reasons to be grateful. Help me develop an eye so I am constantly aware of how You bless me. I pray for a grateful heart and that You will help me cultivate a grateful spirit.

Acknowledge

blessings

big and small.

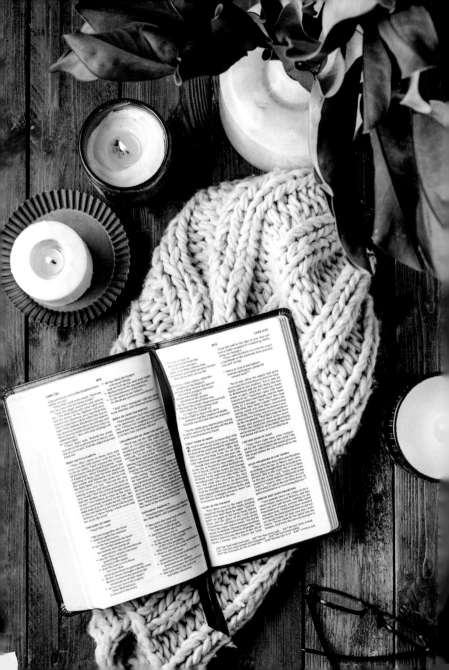

Advent

Therefore the Lord himself will give you
a sign: The virgin will conceive and give
birth to a son, and will call him Immanuel.

ISAIAH 7:14

As the Christmas season approaches, you might look at your to-do list and fear that it's longer than the hours you have in the day. Holiday shopping, decorating, baking, parties, and Christmas pageants are all fun—but when they come on top of an already tight schedule, it's difficult to manage it all. Before you know it, you're rushing from one event to the next, and by the end of December, the thing you want most for Christmas is a good, long nap.

The Advent season is an invitation to slow down, reflect, and savor the moment. It's a time of waiting that prepares your heart and mind to celebrate the birth of Christ. Keep in mind that it's possible to attend every holiday event, buy the perfect

gifts, decorate your home in a Pinterest-worthy manner, and still miss the true meaning of Christmas. But don't worry—you don't have to compromise your to-do list; you'll still get your shopping finished and the tree decorated.

A big part of observing Advent is shifting your thoughts to focus on *why* you're celebrating. So this holiday season, give yourself permission to slow down and be present in the moment. Reflect on the things that make Christmas meaningful. Spend time contemplating why your life is different because Jesus was born. If you do these things—no matter how busy your schedule is—you won't miss Christmas.

Lord, You were always busy and yet never rushed. Please help me make the best use of my time this Christmas season. Teach me to prioritize what is most important and disregard what's not. Jesus, help me center my heart on You through every holiday tradition.

Immanuel

All this took place to fulfill what the
Lord had said through the prophet: "The
virgin will conceive and give birth to a
son, and they will call him Immanuel"
(which means "God with us").

MATTHEW 1:22–23

Sometimes it feels like God is far away, but Christmas
reminds us that He is constantly with us. In the Old
Testament, the prophet Isaiah said a virgin would give birth to
a Son called Immanuel, which means "God is with us." Isaiah's
words were fulfilled when the virgin Mary gave birth to Jesus,
and God chose to take on human form so He could be with His
people—people like you and me.

How might you be encouraged if you were mindful that
God is always with you? God is with you as you wait in long lines
at the mall or in holiday traffic. God is with you as you miss a

loved one you won't see this year. God is with you as you worry about eating Christmas dinner with a difficult family member. God is with you when you drop your kids off at school—and your third grader tells you he needs a Rudolph costume for the Christmas pageant tomorrow night. (And by the way, would you run to the store for a list of supplies and get that made today?) No matter the circumstance—however big or small—God is with you. This holiday season, the best gift you can give yourself is to celebrate that you are never alone. Love Himself walks with you.

Lord, thank You for Your nearness. Thank You for never leaving me. Help me remember that You are always with me, and I can draw strength from You. I thank You because I am never alone, and You are always present to help.

Love
Himself

walks with you.

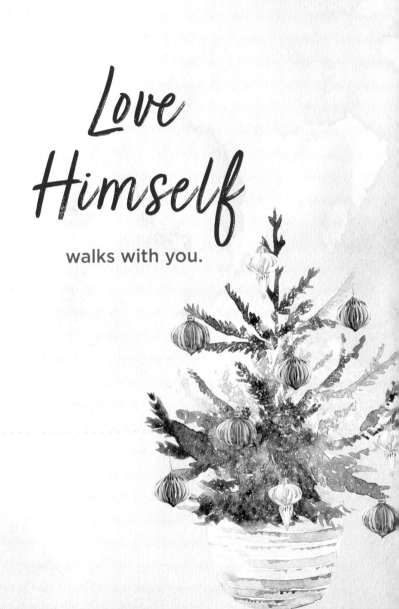

Peace

is a perfect communion with

Love

itself.

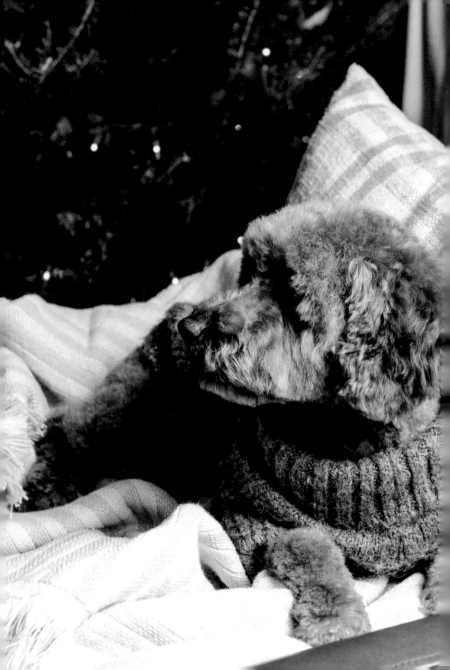

Peace

Glory to God in the highest
heaven, and on earth peace to
those on whom his favor rests.

LUKE 2:14

Seekers go to extreme lengths to find peace but often look for it in the wrong places. Those extra letters after your name, a well-designed home, an extra-long list of addresses to mail your Christmas cards to, and some cushion at the bank are all blessings to enjoy, but none of these things will bring peace.

To have peace means to be in harmony with God. Peace is a perfect communion with Love itself, and it is available to each and every one of us. To be a person of peace doesn't mean your life will be without trial or conflict. But if you know Jesus, you'll find it's possible to have peace in the middle of a conflict because you know God loves you and will take care of you regardless of your circumstances.

Peace isn't an emotion you can manufacture on your own. It's actually a gift given to us by our Savior. Jesus told His followers, "Peace I leave with you; my peace I give you. I do not give to you as the world gives. Do not let your hearts be troubled and do not be afraid" (John 14:27).

You see, God generously invites you to be filled with His peace this Christmas season and every day of the year. He is a good and loving Father, and He delights to deliver.

Jesus, You are the Prince of Peace, and I pray You will fill me with Your peace this holiday season. Teach me to trust in Your love and goodness. Help me have faith that You will do as You have promised.

Rest

There remains, then, a Sabbath-rest
for the people of God; for anyone who
enters God's rest also rests from their
works, just as God did from his.

HEBREWS 4:9-10

Rushing back and forth to the grocery store to grab forgotten ingredients, wrangling the little ones for the perfect Christmas photo, standing in long lines to secure the best presents—there's nothing bad here! But if you're not careful with your expectations of what you can get done day by day, you may find yourself running ragged by Christmas Day.

Deep down, you know this isn't the most enjoyable way to celebrate the Christmas season. God designed your body in such a way that it needs rest—and God encourages embracing

a rhythm of intentional rest, so much so that He even included rest in the Ten Commandments (Exodus 20:8).

The holiday season is meant to be savored, yet so many of us never let the spirit of Christmas settle into our hearts. Rather than running yourself ragged, why not budget some time to rest your body and refill your spirit? That might mean spending an afternoon curled up on the couch with a cup of hot chocolate and watching Christmas movies. It might include going for a drive and looking at decorations with your loved ones. Or maybe it's something as simple as taking some uninterrupted time to relax and listen to your favorite holiday music. There's no right or wrong way to embrace a spirit of rest; do whatever rests your body and refills your soul. But you'll need to be intentional, or it probably won't happen. Prayerfully consider what matters most this season and invite the word *no* into your life this year. Rest is a good gift from the Lord, and we are at our best when we embrace it.

Lord, thank You for encouraging me to rest. Give me the wisdom to know when it's time to rest my body and refill my spirit.

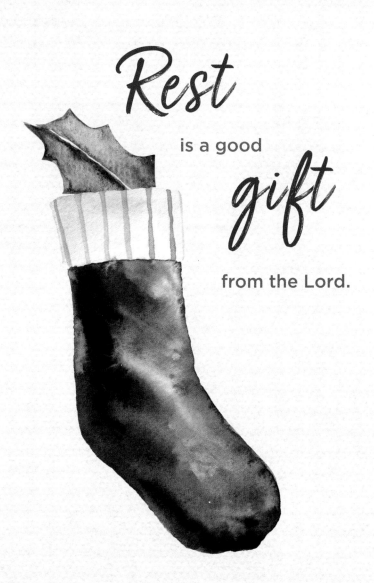

Rest is a good *gift* from the Lord.

Love

And so we know and rely on the love God
has for us. God is love. Whoever lives
in love lives in God, and God in them.

1 JOHN 4:16

God has numerous qualities and characteristics, but nothing defines His character more than love. So, what does God's love mean for you this holiday season?

Christmas is the time of year when we celebrate God's love for us by showing love to others. The love of God for you is joyful, never-ending, unbreakable, and completely secure. As you deepen your knowledge and experience of this kind of love, you may find yourself eager to love others the way God loves you—with the intention of giving love abundantly whether or not you receive it in return.

God's love for us even helps us love the folks we may not

particularly enjoy. Jesus said, "A new command I give you: Love one another. As I have loved you, so you must love one another. By this everyone will know that you are my disciples, if you love one another" (John 13:34–35).

The holidays can be a hard time for many people, so it's an especially important time to approach others with a spirit of love. It doesn't have to be a grand gesture—the best way to show love is through acts of kindness. The overworked barista making your pumpkin spice latte would surely benefit from your encouragement. And your cranky "get off my lawn" neighbor might appreciate some Christmas cookies. Handwritten notes, words of appreciation, assuming the best of others, and simply showing up to say hello embody the spirit of Christmas and go a long way in spreading God's love.

God, teach me to love others the way You love me. Help me be so aware of Your love for me that I am free to love others sacrificially. Lead me to the people who need to be loved.

Bright

The people walking in darkness have seen
a great light; on those living in the land
of deep darkness a light has dawned.

ISAIAH 9:2

Over the years, you've probably come to favor some holiday traditions. A favorite for many is that first moment you plug in the Christmas tree lights in your home. After laboring over the setup, hanging ornaments, and stringing the lights round and round, it's such a relief to finally see your tree shine brightly in your living room.

During this time of year, keep an eye out for a quality of brightness. Brightness might come from sparkling lights, shiny paper, glossy ornaments, or a glimmer in a child's eyes. Or maybe you'll hear brightness in a Christmas carol, church bells ringing, a kind word from a stranger, or the laughter of a

loved one. Sometimes brightness shines in your spirit during a moment of quiet gratitude.

As you celebrate the season, keep your eyes and ears open for all that is bright. Brightness is all around you, and you don't want to miss it. Because of Jesus' birth, brightness reigns—and it's worth celebrating.

Jesus, because of Your birth, the world is filled with brightness. I don't want to miss it. Help me see and savor the brightness in the world around me. And help me be a bright light to others.

Brightness

is all around you,

and you don't want to miss it.

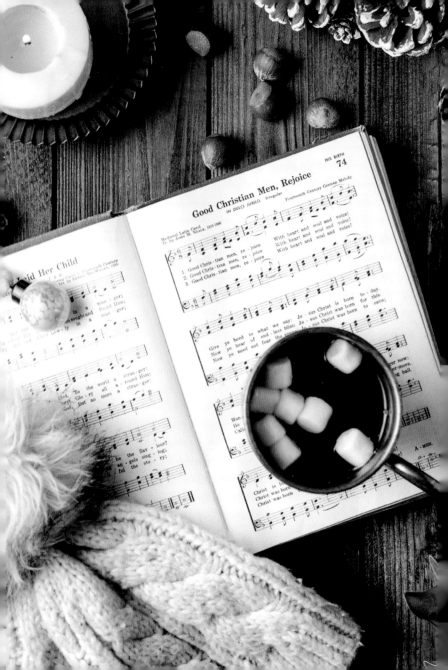

NINE

Praise

I will extol the LORD at all times; his
praise will always be on my lips.

PSALM 34:1

On the night Christ was born, a group of angels appeared and immediately began praising the Christ child (Luke 2:13–14). It was an appropriate response—after all, the Savior of the world had been born! Like these angels, all human beings are wired to praise. Think about it—your first response is to tell everyone when you find someone or something you love. When you're captivated, it's hard to keep it to yourself. The holiday season is the perfect time to contemplate all the reasons why Jesus is worthy of your praise.

Remember, God doesn't need praise—He is entirely self-sufficient (Psalm 50:12). But the reality is, you need to praise Him. Why? The main reason is that He is worthy. Who has done more for you than Jesus? Secondly, praise is beneficial to you.

The praising of God will reshape your heart and mold your mind to be attuned to the glory and power of God. When you praise God and magnify His name, your faith will grow. Praise helps us stay awake to wonder. Praise reminds us of His might and our meekness, and it focuses our minds on the splendor of experiencing a relationship with a good, good God.

With some intentionality, you can make praise a meaningful part of how you celebrate Advent this year. Make a list of your greatest blessings and praise God for His goodness in providing them. Turn on a playlist of your favorite Christmas hymns, and don't be afraid to sing along! Take some time reading through the birth of Christ in the book of Luke. Go slowly and pay attention for the glory hidden in every verse. Watch and see how you find the Christmas spirit.

Jesus, You are the Savior of the world and worthy of all praise. Thank You for your goodness, faithfulness, and holiness. Help me make praising You a regular part of my daily rhythm.

TEN

Salvation

"Salvation is found in no one else, for
there is no other name under heaven given
to mankind by which we must be saved."

ACTS 4:12

Christmas is the world's biggest birthday party. What other birthday calls for a global celebration? Millions of gifts are exchanged, parties are thrown worldwide, meals are prepared that delight the taste buds of many nations, and songs are sung in a variety of languages. Jesus' birthday is unlike any other because He is unlike anyone else. Jesus is the author of salvation—a title reserved only for Him (Hebrews 2:10 AMP).

You might think being a Christian is reserved for people who have it all together, but in fact, it's quite the opposite. You see, if you follow Jesus, you have to admit that you can't do this life on your own. You have to admit that you need help. You have to admit that you're far from perfect and even far from God. But

29

the good news is, Jesus literally came to bring you to Him, at no cost to you.

God's salvation is a free gift of His grace offered to all people, and the only means of salvation is through the person of Jesus Christ (Ephesians 2:8–9). Jesus told His disciples, "I am the way and the truth and the life. No one comes to the Father except through me" (John 14:6).

This Advent season, let go of your worries and rejoice in the Author of your salvation. Join along with believers across the globe who celebrate Him! It's a good party!

Jesus, You are the way, the truth, and the life. Thank You that all people can find salvation in You. I celebrate Your birth and exalt Your name!

Jesus'

birthday

is unlike any other because He is

unlike

anyone else.

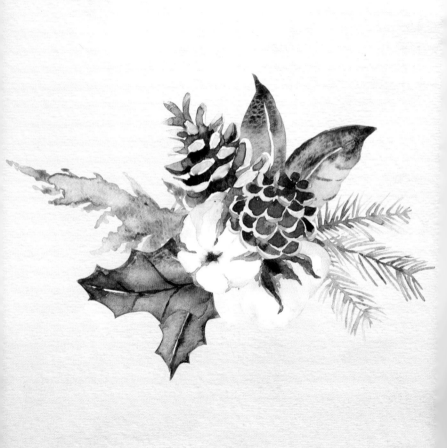

Jesus coming into the

world

is the greatest act of

kindness

in history.

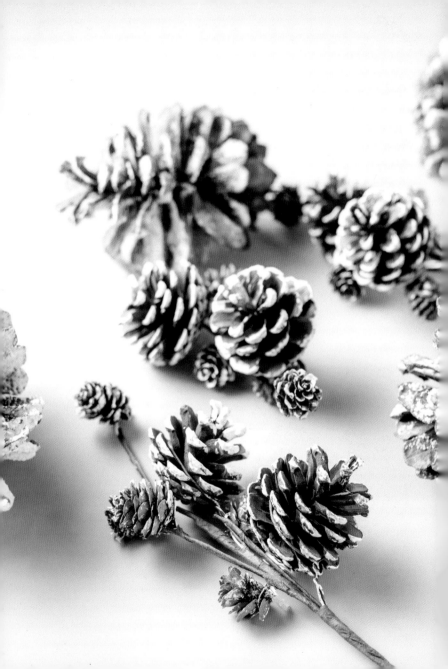

Kindness

Be kind and compassionate to one
another, forgiving each other, just
as in Christ God forgave you.

EPHESIANS 4:32

I f you think back over past holiday seasons, you can probably recall a gesture of kindness that was especially meaningful to you. It might have been a thoughtful gift, a favor, or an especially enjoyable visit. Acts of kindness are seldom the biggest or shiniest gift under the tree, yet they are priceless—because they communicate how much the giver cares.

Jesus coming into the world is the greatest act of kindness in history. Why? The path from the manger would lead to the cross, where Jesus would take on the sins of the world (John 3:16). Pause and consider just a few of the ways God has lavished you with extravagant acts of kindness.

Because of Jesus, you can stand before God, completely

forgiven of all past, present, and future sins. You are free to enjoy God's peace, favor, and blessing. In His kindness, God has provided countless things to enjoy—from simple pleasures like hot chocolate and a decorated tree to the beautiful mountains and oceans and beaches that cover the earth.

As you bask in the kindness of God, pray that His kindness would take hold of your heart. As a child of God, you have the capacity to be the kindest person in your town, workplace, and neighborhood. The apostle Paul wrote, "Be kind and compassionate to one another, forgiving each other, just as in Christ God forgave you" (Ephesians 4:32). Who do you know who could use some kindness? Christmas is the season for kindness—but go ahead and make it every day of the year!

God, thank You for the countless ways You have lavished acts of kindness on me. Help me see the ways You are kind, and lead me to people who need my kindness.

Harmony

Sing to the LORD, all the earth; proclaim
his salvation day after day.

1 CHRONICLES 16:23

I f you've ever listened to a holiday symphony, you've witnessed what's possible when a group of musicians comes together with the common goal of creating something beautiful. It takes string, brass, woodwind, and percussive instruments to allow a symphony to achieve its sound. If any of those sections were missing, the symphony would be lacking, and even an untrained ear could likely tell the difference. Diversity—not sameness—empowers musicians to achieve something together they could not create on their own.

In the same way, Christmastime is a richer experience when we celebrate in harmony with other people. The holidays are a time to spend with friends, family, and loved ones. But it's also an ideal time to add additional chairs to your table

and connect with new friends or people you haven't seen in a long time. Celebrating together amplifies your worship when you realize you are part of an enormous body of believers from nations, ethnicities, and backgrounds that span the globe.

Keep in mind you don't have to agree on every issue to celebrate the birth of Jesus together. The goal isn't sameness—the goal is to glorify Jesus together. Simply agreeing that Jesus is the Christ child and worthy of celebration goes a long way in creating harmony. Imagine the joy you'll experience knowing your voice is one of the millions celebrating that the Christ child is born!

Lord, thank You for the gift of diversity among people. Help me live in perfect harmony with those around me as I celebrate You this season.

Christmastime is a

richer

experience when we celebrate in

harmony

with other people.

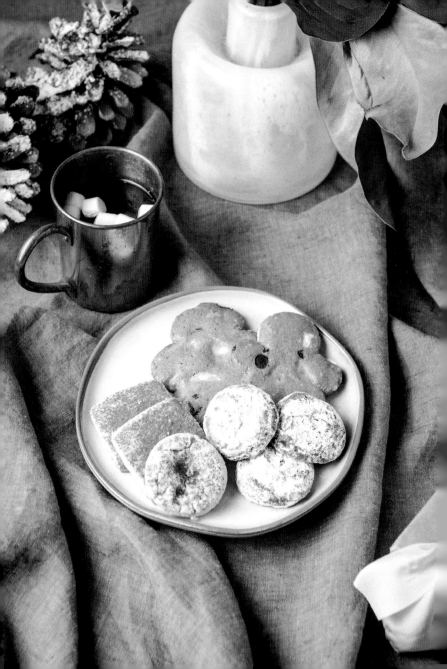

Jolly

Shout for joy to the LORD, all the earth.
Worship the LORD with gladness;
come before him with joyful songs.

PSALM 100:1-2

You've probably sung along to the old Christmas song "Holly Jolly Christmas" by Johnny Marks, with its sing-song proclamations that this is the best time of the year.

As Christmas morning approaches, you'll have numerous opportunities to find your inner jolliness, but let's be honest—things don't always go the way you plan! So much of life is outside of your control. But you push through with a smile because this is the holly-jolly month, right?

If you want to find genuine jolliness, the first step is to remove the pressure to always be happy. Once you learn to respect the full range of your emotions, good and bad, you'll be able to tend more deeply to the good ones.

Where does jolliness come from? Well, did you especially enjoy that cappuccino you drank before heading out to finish shopping? Savor it. Did the soloist at the Christmas pageant move you? Replay it in your mind. Were you delighted to get an old friend's holiday card in the mail? Celebrate it. Being jolly is most often about embracing the small things that delight you. Take time to slow down and enjoy them. Linger over the sweet moments this season. There may be more than you think.

Lord, help me see all the good reasons I have to be cheerful—even jolly. Teach me to slow down and savor the things I enjoy.

Consequently, faith comes from hearing
the message, and the message is heard
through the word about Christ.

ROMANS 10:17

Before Jesus' birth, some people had been anticipating His coming. The Old Testament prophets had said Jesus, the Savior, would be born (Isaiah 9:6), and God's faithful people believed those words were true. While they didn't have any tangible proof that these promises would be fulfilled, they still had faith they would happen. Simply put, faith can be defined as believing Jesus' claims about Himself and that He will keep His promises.

Maybe this holiday season, you find yourself wishing you had more faith. If that's true, you are in good company. Even Jesus' disciples wished for more faith, and they went as far as to

ask for more of it. The Gospel writer Luke wrote, "The apostles said to the Lord, 'Increase our faith!'" (Luke 17:5).

Faith is a gift that God delights in giving—so go ahead and ask Him for more of it! Another way to grow in faith is to think about all the ways God has come through for you in the past. Recalling how God has cared for you in previous situations builds faith that He will continue to do so in the future. Jesus came in the form of a baby to be the Savior of the world—and those who follow Him walk by faith. This Christmas season is the perfect time to celebrate that Jesus is who He says He is and that He does keep His promises.

Lord, increase my faith. In every situation, help me believe that You are who You say You are and will keep Your promises.

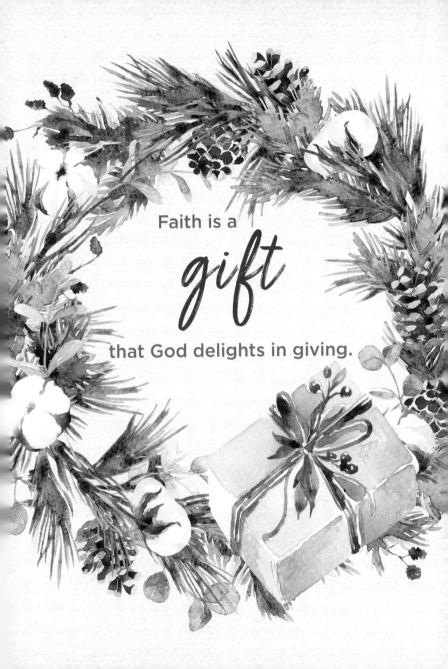

Faith is a

gift

that God delights in giving.

Wonder

He is the one you praise; he is
your God, who performed for you
those great and awesome wonders
you saw with your own eyes.

DEUTERONOMY 10:21

Have you ever watched a child's face light up at the sight of a gingerbread house, an ice-skating rink, or a Christmas tree surrounded by gifts? Children naturally view their surroundings with curiosity and a fresh perspective, and one of the most enjoyable ways to experience the wonder of the Christmas season is through the eyes of a child.

Thankfully, experiencing wonder doesn't have to end in childhood—adults can embrace a posture of wonder too. How? Tune in.

God has created a world filled with glints of His grace, but

if you're distracted, you might miss them. Wonder might arrive in the beauty of fresh snow blanketing the lawn, a roaring fireplace, a performance of Handel's *Messiah*, or something as simple as the feeling of a warm scarf on a cold day. Or perhaps wonder might come as you walk through nature or read a part of God's Word, given to you as a gift. The greatest wonder of all is that God loved humankind so much that He was willing to send His Son to be the Savior of the world. Make it a point to stay wide-eyed this year. Wonder will keep you young at heart and living with anticipation. With that in mind, you might want to live with wonder every day of the year!

Lord, thank You for creating the world in such a way that there are plenty of things to marvel at. Fill me with childlike wonder and help me have eyes that see wonder everywhere I look.

Light

"The people living in darkness have seen
a great light; on those living in the land of
the shadow of death a light has dawned."

MATTHEW 4:16

Displaying lights is one of the ways people all over the world celebrate Christmas. From Bethlehem to New York City, and every place in between, people decorate with lights during the Christmas season. You'll see holiday lights hung on houses, Christmas trees, skyscrapers, apartment buildings, porches, wreaths, mantels, and even automobiles.

Decorating with light is a symbolic way to celebrate Jesus' coming into the world. In the Bible, and especially in the Gospel of John, there is a theme of light and darkness. Apart from Jesus, the world is dark, but the Christmas story tells of light shining in the darkness. Jesus said, "I am the light of the

world. Whoever follows me will never walk in darkness, but will have the light of life" (John 8:12).

As you take in the Christmas lights this year, let them be a reminder that Jesus is the Light of the World. Be encouraged because there is no darkness that Jesus can't overcome. As you follow Jesus, you have His light within you. When you extend kindness, gratitude, patience, and meekness, your spirit will shine even brighter than the most brilliant light in the world. This Christmas season, look for opportunities to share that light with people who need it.

Jesus, I praise You for being the Light of the World. Thank You that I never have to walk in darkness. Lord, help me walk in Your light and share Your light with others.

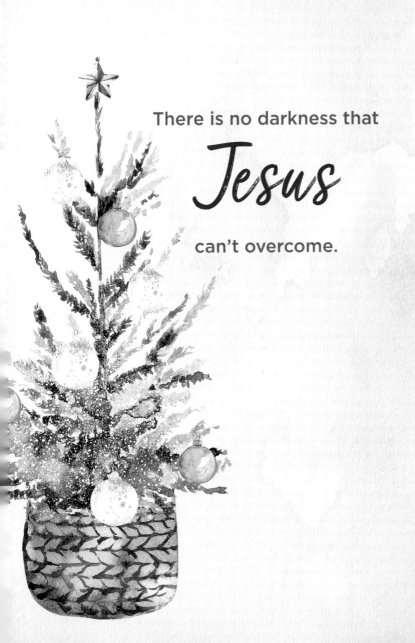

There is no darkness that

Jesus

can't overcome.

Jesus brought *joy* at His birth.

SEVENTEEN

Joy

But the angel said to them, "Do not be
afraid. I bring you good news that will
cause great joy for all the people. Today
in the town of David a Savior has been
born to you; he is the Messiah, the Lord."

LUKE 2:10–11

In the Gospel of Luke, you'll find a fascinating piece of information tucked inside the angel's announcement about the birth of Christ. Interestingly, the angel said, "I bring you good news that will cause great joy for all the people." Pause and think about that phrase for a moment: "great joy for all the people." Notice how Jesus' birth meant instantaneous joy for everyone.

Happiness comes and goes, but the joy the Bible talks about is a gift from God and comes from being in a relationship

55

with Him. Joy runs deeper than happiness and isn't dependent on outward circumstances. It's available in times of ease or trouble because it's an inner satisfaction found in God. The psalmist wrote, "You make known to me the path of life; you will fill me with joy in your presence, with eternal pleasures at your right hand" (Psalm 16:11).

This holiday season may stir up a range of emotions—happiness, anger, loneliness, fear—all of which are valid. But as you meditate on Christ's birth, explore what it's like to simply let joy come *alongside* your emotions this year. Jesus brought joy at His birth, and it has echoed through every Christ-follower for the last two thousand years. No matter your circumstances, rest assured that this joy is for you.

God, thank You for the gift of joy. I especially appreciate that joy is available to all people, no matter their circumstances. Help me experience joy in my relationship with You.

Hope

And hope does not put us to shame,
because God's love has been poured
out into our hearts through the Holy
Spirit, who has been given to us.

ROMANS 5:5

For children (and some of us adults), one of the most exciting things about Christmas is thinking about your wish list and hoping for the best. If you think back to the holidays you had when you were a child, you might remember being delighted on Christmas morning—or maybe there was a time or two you felt a tinge of disappointment.

The good news is that because Jesus came as the Savior of the world, you can embrace a hope that will never disappoint you (Romans 5:5). Biblical hope is not passive in the sense that you hope for a specific gift or you hope it snows on Christmas

Eve. Biblical hope is an active anticipation that God will bring good things to pass. It's based on His track record of pure goodness and perfect faithfulness. God has already given you the best gift you will ever receive—His Son. Through the gift of Jesus Christ, you can enjoy peace with God, the forgiveness of sins, and the confidence that He will care for you every day of your life. Even more, you will spend eternity with Him. Now that is some gift! This Christmas, you can confidently embrace hope with certainty—knowing you will see God's goodness (Psalm 27:13).

God, thank You that You have given me a reason to hope. Fill me with active anticipation of Your goodness. Teach me to live with confidence that good things are coming.

God has already given you the

best gift

you will ever receive.

Trust

Trust in the Lord with all your heart and
lean not on your own understanding;
in all your ways submit to him, and
he will make your paths straight.

PROVERBS 3:5-6

Each year when the Christmas story is told, we hear the account of Mary and Joseph traveling to Bethlehem, where she would give birth to Jesus in a stable. One thing that isn't always mentioned is how the birth of Christ couldn't have unfolded the way it did without a great level of trust. When Mary and Joseph learned she would give birth to the Christ child, they were in a unique situation, to say the least. No one in the history of humankind has ever experienced a similar scenario—and they had to trust God with overwhelming obstacles.

Mary and Joseph had to trust that they had understood correctly and that, by a miracle of God, Mary would indeed give birth to the Son of God (Luke 1:26–31; Matthew 1:20–21). They had to announce a controversial pregnancy (Luke 1:34), travel under challenging circumstances (Luke 2:1–5), make the best of limited financial resources (v. 24), and flee to Egypt as refugees when they learned King Herod wanted to kill Jesus (Matthew 2:13). And in every instance, God proved faithful.

God always does what He says He's going to do.

This Christmas season, rest in the fact that God is trustworthy. God doesn't overlook a single detail, and He provides in ways you could never imagine. Your role is to trust Him even when you can't see how things will work out. The story of Jesus' birth demonstrates that you can trust God with the impossible.

God, thank You for being trustworthy. Help me trust You in every area of my life. As You did for Mary and Joseph, teach me to obey You even when I can't see the final outcome.

Calm

But I have calmed and quieted myself,
I am like a weaned child with its mother;
like a weaned child I am content.

PSALM 131:2

The mistletoe is hung, the cranberry sauce is made, and the roasted potatoes are steaming in the oven. Everything is perfect, and now you need a full eleven months to recover!

Let's be honest—hosting a holiday gathering is such a delight, but it can be stressful. But rather than aiming for perfection (which is boring anyway), why not view hosting as an opportunity to invite others into a space of calm? It's not about preparing the perfect meal or showcasing your home. It's about creating a space for your guests to come together and celebrate. At the end of the party, your guests probably won't remember exact specifics about the meal or the table setting, but they will

remember the conversations and the connections they made with others.

For better or worse, the host sets the emotional temperature of the gathering, and if you're stressed out, the guests will sense it. But if you're calm and relaxed, they will be too. So let go of the notion of perfection and resist the temptation to be a kitchen martyr. Ask other guests to bring side dishes. If you can, buy some items that reduce the workload. Frozen vegetables, anyone? Premade crusts? If it takes some stress off you, then that's a great way to celebrate the season. Jesus said, "The greatest among you will be your servant" (Matthew 23:11). If you approach the gathering as a way to be kind and serve your guests, at the end of the day, when exhaustion sets in, you'll be glad you did.

Jesus, help me approach every situation this season with a sense of calm. Help me remember that only You are perfect and that I can release myself from the aim of perfection. Help me be a good host and serve people well.

Let go

of the notion of perfection.

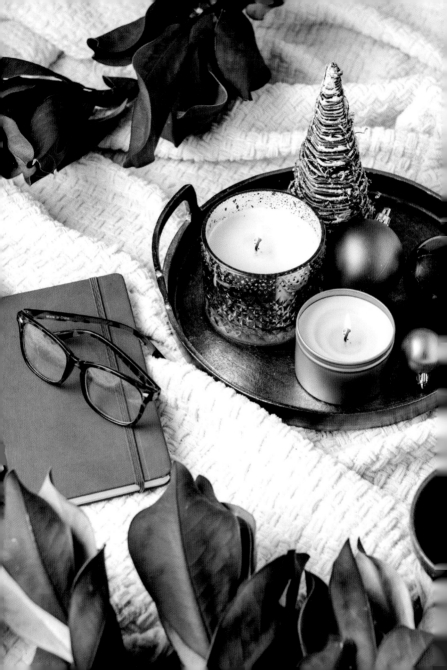

TWENTY-ONE

Miracle

How shall we escape if we ignore so great
a salvation? This salvation, which was first
announced by the Lord, was confirmed
to us by those who heard him. God also
testified to it by signs, wonders and
various miracles, and by gifts of the Holy
Spirit distributed according to his will.

HEBREWS 2:3–4

Have you contemplated the miracle of Christmas? *Miracle* is a word that gets thrown around a lot and is sometimes used out of context in our culture, but Christmas is a time for us to recenter our hearts on just how wild God really is.

Miracles are remarkable events that can't take place apart from God's power. Have you ever paused to consider that you've already received a Christmas miracle? Think about it. God

planned that Jesus—the Savior of the world—would be born of the virgin Mary (Isaiah 7:14) and that those who have faith in Jesus would be saved from their sins and reconciled to God (John 14:1–4; Luke 19:10). God's gift of salvation came in the form of the miracle of Christ's birth. If you follow Christ as Lord, you are the recipient of a Christmas miracle!

Christmastime is the ideal time to reflect on the reality that God is in the miracle business and routinely accomplishes the impossible. Is there a specific area in your life where you need God to work? Be encouraged that you serve a God who can do all things.

Lord, I praise You for the miracle of Christ's birth. Help me remember that You can do the impossible. I ask You to work in my life and bring things to pass that I can't make happen on my own.

Believe

>"'If you can'?" said Jesus. "Everything
is possible for one who believes."
Immediately the boy's father
exclaimed, "I do believe; help
me overcome my unbelief!"
>
>**MARK 9:23–24**

During the holiday season, you've probably seen festive signs that read, "Just believe." It's a message that stirs up holiday excitement in kids and is a fun way to celebrate the holiday season. But as you grow older, you need a good reason to believe—and something more substantial than a cute message on a sign. The good news is that Jesus has a lot to teach about the topic of believing.

There's a story in the Bible of a father who brought his sick son to Jesus. The father was discouraged and running low on

faith because his son had been sick since childhood, and the problem continued to get worse (Mark 9:14–21). Jesus asked the father some questions, and when the father answered Jesus, he said, "But if you can do anything, take pity on us and help us" (v. 22).

Jesus understood the man's discouragement and answered, "'Everything is possible for one who believes.' Immediately the boy's father exclaimed, 'I do believe; help me overcome my unbelief!'" (Mark 9:23–24). The father was honest with Jesus, and even though he was struggling to believe, he asked Jesus to help him have more faith. Jesus answered his requests by healing his son, and undoubtedly the father's faith grew as a result.

What do you need from God this holiday season? You don't have to have perfect faith for God to answer your prayers. Go ahead and ask—and don't hesitate to ask Him to help you believe.

Jesus, I do believe, but I want to have more faith. Like the father of the sick son, I pray, "I do believe; help me overcome my unbelief!"

You don't have to have perfect

faith

for God to answer your

prayers.

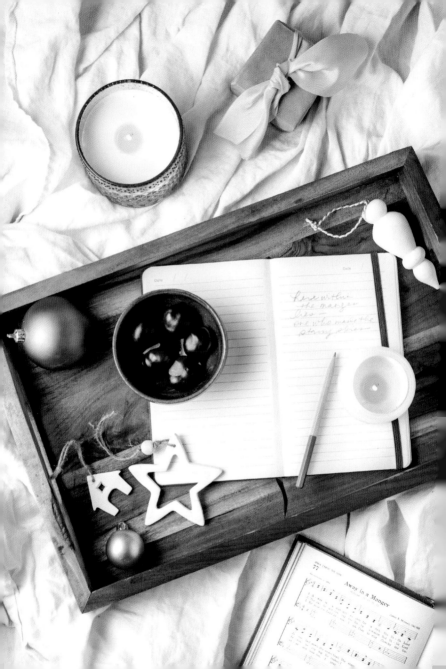

TWENTY-THREE

Suddenly a great company of the
heavenly host appeared with the angel,
praising God and saying, "Glory to God in
the highest heaven, and on earth peace
to those on whom his favor rests."

LUKE 2:13–14

Songs have been sung in honor of Christ's birth since the night He was born. The lyrics sung by the group of angels in the Gospel of Luke are often repeated in Christmas Eve services in the modern-day masterpiece "Gloria in Excelsis Deo," which translates to "Glory to God in the Highest."[1]

What does it mean to give glory to God? To give glory to God doesn't mean to give God something He lacks—it means to proclaim the magnificent glory He already possesses. God's glory can be defined as all the things that make Him heavenly—His

omniscience, omnipotence, and perfect love. Meditate on that for a minute. It's quite magnificent, isn't it? So magnificent that all of God's creation even declares His glory. The psalmist wrote, "The heavens declare the glory of God; the skies proclaim the work of his hands" (Psalm 19:1).

This holiday season, if you want to bask in God's glory, simply take a look around. Evidence of God's glory is written in all His creations—the landscape, sky, animals, flowers, and vegetation. It's in sunrises, sunsets, and the face of a child. You'll even see God's glory in the mirror! That's right—God's glory is displayed in you, and everyone around you, because all human beings are made in the image of God (Genesis 1:27).

Practically speaking, what are some ways you can bring your heart into alignment with God's glory this Advent season? Prayer, praise and worship, and simply enjoying and speaking about God's wonderful characteristics are all practical ways you can give glory to God. Sing your favorite Christmas song with a heart full of admiration toward God, and without even realizing it, you'll be proclaiming the glory of God.

God, You are the God of glory, and You have filled the world with reason to praise You. Give me eyes that recognize Your glory in big and small ways. Let my life proclaim Your glory every day of the year.

"*Gloria*

in Excelsis Deo."

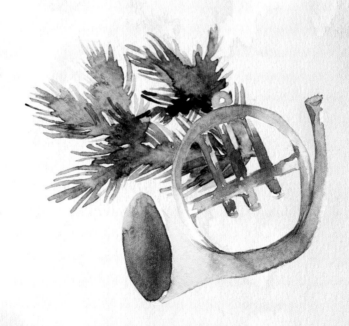

Messiah

Today in the town of David a
Savior has been born to you; he
is the Messiah, the Lord.

LUKE 2:11

When the angel appeared to Joseph and told him about Mary's pregnancy, the angel instructed Joseph on what to name the baby in Mary's womb: "She will give birth to a son, and you are to give him the name Jesus, because he will save his people from their sins" (Matthew 1:21).

As you celebrate Advent, you might notice that Jesus is called by several names: Savior, Son of God, Lord, Wonderful Counselor, Mighty God, and Prince of Peace, to name a few. Jesus' identity is so powerful that it takes numerous names to describe His characteristics and attributes. *Messiah* is a name for Jesus that means "anointed one," especially as it relates to

Jesus being born a king.[2] In other words, Jesus was set apart for God's service, and He alone has the power to save His people from their sins (Matthew 1:21).

As you prepare your heart and mind to celebrate Christmas, spend some time thinking about the different names that refer to Jesus. Which one resonates most with you right now? Jesus came to save you from your sins, but the good news doesn't stop there. Jesus also came to help you live with peace and joy during your time here on earth. You can be encouraged that whatever needs or longings you have, Jesus has the power, character, and identity to meet those needs—and He is willing.

Jesus, I praise You because You are the anointed Messiah. You are the answer to my every need and longing.

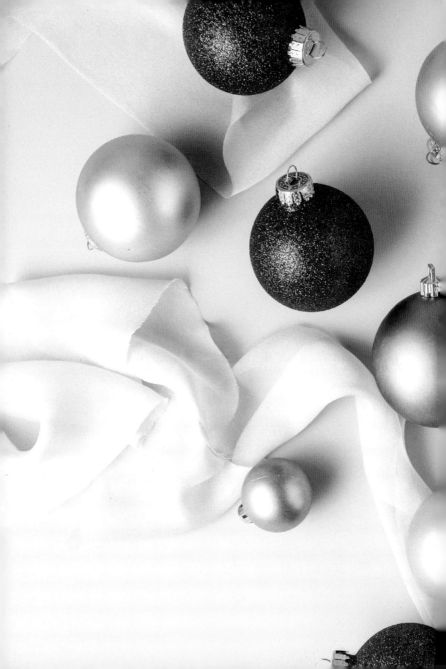

Messiah

is a name for Jesus that means

"*anointed*

one."

Ponder

But Mary treasured up all these things
and pondered them in her heart.

LUKE 2:19

H ave you experienced something so wonderful that you were still thinking about it days later? After Jesus was born, Mary and Joseph were visited by shepherds who reported the things they had heard about Jesus (Luke 2:17–18). All who heard it were amazed, but Luke said, "Mary treasured up all these things and pondered them in her heart" (v. 19). Mary already knew she had given birth to the Savior, but it took some time to let it set in. She stole some time to reflect on the goodness and hope that lay asleep in her arms.

The Advent season is the perfect time to reflect on things you treasure. Maybe you'd like to spend some time reflecting on the Christmas story or on another portion of Scripture.

Or perhaps you'd like to set aside time this holiday season to reflect on the people and things you treasured most over the past year. Or maybe you'd benefit from reflecting on an especially enjoyable gathering or event you experienced. As you reflect, ask yourself some questions: *What makes this meaningful to me? What parts do I treasure and why? What should my response to this be?* The things that matter most deserve your reflection. Taking the time to reflect seals the things you treasure in your heart and mind in a way that wouldn't happen otherwise. If you take the time, you'll be glad you did.

Lord, thank You for giving me things to treasure and reflect on. Help me reflect on things so they become even more meaningful.

TWENTY-SIX

Adoration

On coming to the house, they saw
the child with his mother Mary, and
they bowed down and worshiped
him. Then they opened their treasures
and presented him with gifts of
gold, frankincense and myrrh.

MATTHEW 2:11

I f you've ever watched a Christmas pageant, you've undoubtedly seen children depict the wise men going to visit baby Jesus and presenting Him with gifts (Matthew 2:10–11). There's nothing cuter than watching young children dressed up in makeshift costumes attempting to pronounce *frankincense*. Christmas pageants are a tradition everyone loves and an important way for kids to learn about the Christmas story.

In Matthew's account of the wise men going to worship the baby Jesus, he says the men "bowed down and worshiped him,"

and then they presented the Christ child with gifts. Keep in mind, these were grown men bowing down to an infant. But the Christ child was different from all other infants—Jesus was the Son of God. The wise men went to great lengths to show adoration for Jesus because they understood this was no ordinary baby.

As you prepare your heart and mind to celebrate Christmas, why not spend a few minutes identifying the specific reasons you adore Jesus? Is it a particular Bible story? Is there something in your personal story that makes you especially grateful? Did Jesus come through for you in a way you never expected? This Advent season, spend a few minutes telling Jesus why you adore Him. Name the reasons for your adoration and, like the wise men, set them like gifts at His feet.

Jesus, I adore You for coming to earth as the Son of God and for taking on the sins of the world. I adore You for coming willingly. Thank You for all the specific ways You've shown love toward me.

Charity

Whoever oppresses the poor shows
contempt for their Maker, but whoever
is kind to the needy honors God.

PROVERBS 14:31

Near the end of the year, along with Christmas cards and special deliveries, your mailbox probably gets packed with correspondence from organizations asking for end-of-year donations. Churches, toy drives, soup kitchens, medical nonprofits, and homeless shelters are all doing their best to provide for those in their care. Salvation Army bells ring outside stores, where volunteers wearing Santa hats are taking donations. If you are looking for ways to give, opportunities abound.

At Christmastime, and every day of the year, one of the best ways to honor God is to provide for people in need. The book of Proverbs teaches that when you give to the poor, you

give honor to God. The Christmas season is a time to celebrate all we have been given in the person of Jesus Christ. Apart from Jesus, everyone is spiritually poor. But at Christmas, we celebrate the fact that God came to meet humankind's greatest need. In response to God's radical generosity, you are called to generosity.

Don't be discouraged if you aren't in a position to give as much as you would like. If you're short on cash, you can give a small amount or donate your time. It's not about a specific dollar amount—it's about having a giving attitude and being willing to help. Everyone can give something, and collectively, it makes a difference. You will not only see the needs of your neighbor met but also experience a kind of joy you've likely never experienced before. When we are generous, we become more and more like our Savior—and there's no better feeling than that.

Jesus, apart from You, I am needy. Thank You for meeting my deepest needs. Help me have a generous attitude and spirit. Provide creative ways for me to meet needs and bring You glory.

Shine

For God, who said, "Let light shine out of
darkness," made his light shine in our hearts
to give us the light of the knowledge of
God's glory displayed in the face of Christ.

2 CORINTHIANS 4:6

When Jesus was born, the wise men were led to the Christ child by a rising star that shone in the darkness and pinpointed Jesus' location (Matthew 2:2, 9). It's not surprising that God used a shining star to lead those first worshipers to Jesus. When God created the earth, His first creative work was to separate light and darkness (Genesis 1:3–4). Interestingly, Jesus called His followers "the light of the world" and said, "Let your light shine before others" (Matthew 5:14–16). Like the star that shone on the night of Christ's birth and pointed the wise men to Jesus, you have an opportunity to shine.

What does it mean to shine? Shining your light might mean telling others why you have put your hope in Jesus. It means being kind when you're tempted to act snarky. Shining your light means choosing to be the person the Bible teaches you to be, even when the rest of the crowd is moving in the opposite direction. The apostle Paul put it this way: "Do everything without grumbling or arguing, so that you may become blameless and pure, 'children of God without fault in a warped and crooked generation.' Then you will shine among them like stars in the sky" (Philippians 2:14–15). Simply put, shining means to stand out among the rest because you're uniquely transforming to be more like Jesus.

Jesus, teach me to live in such a way that my life points people to You. Please help me shine so You are glorified.

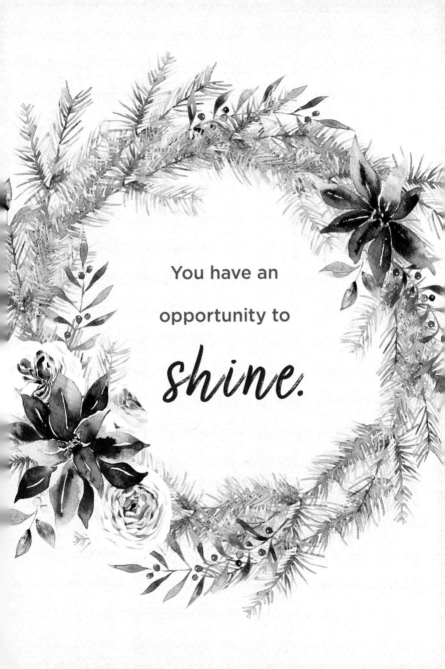

You have an

opportunity to

shine.

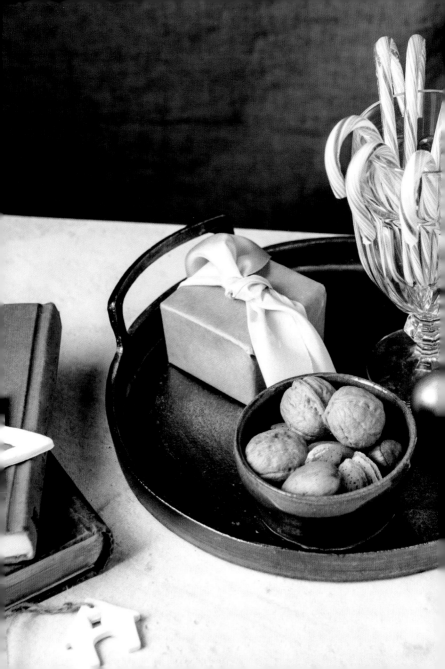

Presence

Therefore if you have any encouragement
from being united with Christ, if any
comfort from his love, if any common
sharing in the Spirit, if any tenderness and
compassion, then make my joy complete
by being like-minded, having the same
love, being one in spirit and of one mind.

PHILIPPIANS 2:1-2

One of the best things about celebrating Christmas is the time spent with loved ones. Memories are made when families crowd around tables to share meals, tell stories, and play board games.

Togetherness represents a special aspect of Christmas because Jesus, the Son of God, took on the form of a man to come to earth to be physically present. Jesus did not have to give mankind the gift of His presence—but He did so willingly.

After all, Immanuel means "God with us" (Matthew 1:23). When we gather with our people at Christmastime, without realizing it, we embody the spirit of Christmas.

When the house gets crowded, the kids are loud, and you discover that someone turned the thermostat to a temperature that would heat the North Pole, rather than running for the hills, embrace the fact that you've got a house filled with loved ones who are present to celebrate with you. Remember, no one has a perfect family (they don't exist), and there will be snags along the way. What matters is that you are together to celebrate Jesus' birthday.

Jesus, thank You for loving us so much that You were willing to be physically present here on earth. Help me demonstrate Your loving spirit by being present with my people this Christmas.

Goodness

Every good and perfect gift is from
above, coming down from the Father
of the heavenly lights, who does not
change like shifting shadows.

JAMES 1:17

Maybe you've heard it said, "God is good," and then some-
one responds, "All the time." And it's true; God is good
all the time. As you progress through this season, take a couple
of extra minutes every morning to remember the extraordi-
nary goodness of God, who sent His son, Jesus Christ. If Jesus
were the only gift God ever gave, you'd have ample reason to
praise Him every day for the rest of your life. Jesus is the great-
est example of God's goodness—but God's goodness extends to
every crack and crevice of life.

Simply put, every good thing you have comes from the

hand of God. King David addressed this with God when he prayed, "I say to the LORD, 'You are my Lord; apart from you I have no good thing'" (Psalm 16:2). Look around and take note of the things you enjoy. Hobbies, pets, music, the beach, mountains, food, laughter, relationships—all are expressions of God's goodness, and by the gift of His grace, He gives you the privilege of enjoying them.

December is a month packed with God's goodness. Holiday meals, parties, gifts, and fellowship can all be traced back to the hand of God. As you enjoy these things, be sure to make the connection that they are expressions of God's goodness. He gave them for you to enjoy! Why? Because He is good!

Lord, I praise You because You are filled with goodness. Thank You for giving me so many good things to enjoy. Help me always acknowledge that every good thing I have comes from You.

It's true; God is

good

all the time.

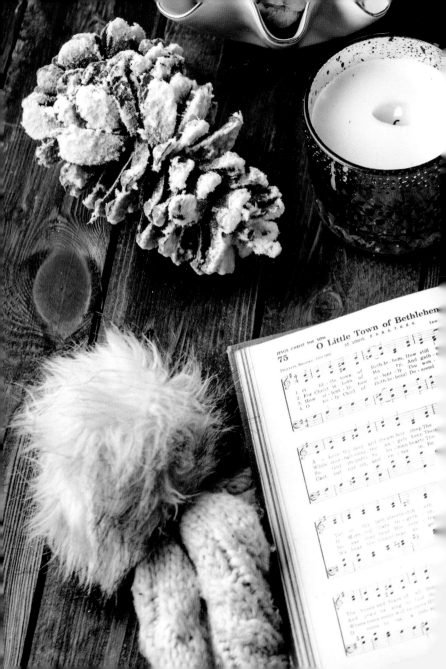

Holy

But just as he who called you is holy,
so be holy in all you do; for it is written:
"Be holy, because I am holy."

1 PETER 1:15–16

I t's likely that you'll hear the ever-popular Christmas carol "O Holy Night" sung this time of year. Maybe you'll even feel stirred to hum along. It's a moving melody, but it's even more compelling when you consider that the lyrics are about a real, true event. The night that Christ was born was a holy night— indeed, it was sacred. *Holy* is a word that means "to be set apart," and it refers to God's unique perfection and pureness.[3] God is completely perfect and without sin. *Holiness* is a word that primarily applies to God, but amazingly, God instructs His people to be holy.

Being holy sounds like a tall order and something reserved

for pastors. But holiness is a characteristic that all believers possess in some measure, and the good news is you can grow in holiness. Apart from Jesus, it would be impossible for anyone to be holy, but part of what it means to know Jesus is that as you follow Him, you become more like Him. And by following Jesus and trying to live as He lived, you will grow in holiness.

God will never ask you to be perfect, nor does He need you to be. But as you continue to walk with God, over time, you're going to find yourself becoming more like Him—operating from love, joy, patience, meekness, and compassion.

God, I praise You for Your holiness. You are pure, and there is nothing false in You. As I follow Jesus, help me grow in holiness.

Humble

"Take my yoke upon you and learn from
me, for I am gentle and humble in heart,
and you will find rest for your souls."

MATTHEW 11:29

The Christmas season is often celebrated with glitz and glamour, and with the addition of social media, it can sometimes feel like a competition to go all out with perfectly styled Christmas trees, camera-ready kiddos, and tablescapes that look like they were copied from a magazine. There's nothing inherently wrong with any of this, but take a close look at your heart. Are you operating from a place of celebration or comparison? If you find parts of this season overwhelming, take a step back. In fact, you'll be closer to the spirit of that first Christmas if you are mindful that everything surrounding Christ's birth was humble—even the location where Jesus was born.

Bethlehem is located about five miles southwest of Jerusalem. At the time of Jesus' birth, it was described as small in both size and significance. In comparison to Jerusalem, Bethlehem didn't have much to offer. It was so obscure that it wasn't even named among the one-hundred-plus cities assigned to the tribe of Judah (Joshua 15:21–62). Despite its humble stature, God chose this unremarkable village to serve as the birthplace of Christ.

The town of Bethlehem possessed nothing remarkable, yet it became the site of the most significant birth in human history. But if you study the Scriptures, you'll see a consistent pattern of God choosing people and places the world overlooks. It seems God takes great pleasure in choosing humble people and places to do extraordinary things. Mary and Joseph were ordinary people, and Bethlehem was a humble location.

This Christmas, let the humble circumstances of Christ's birth help you unwind and embrace simplicity. God can take ordinary people and places and do extraordinary things. No need to perform; reclaim your peace this year. Rest easy knowing God is always ready to do extraordinary things through you.

Jesus, thank You that You were willing to come to earth in the most humble of circumstances. Thank You for doing extraordinary things through ordinary people.

God takes great pleasure

in choosing

humble

people and places to do

extraordinary

things.

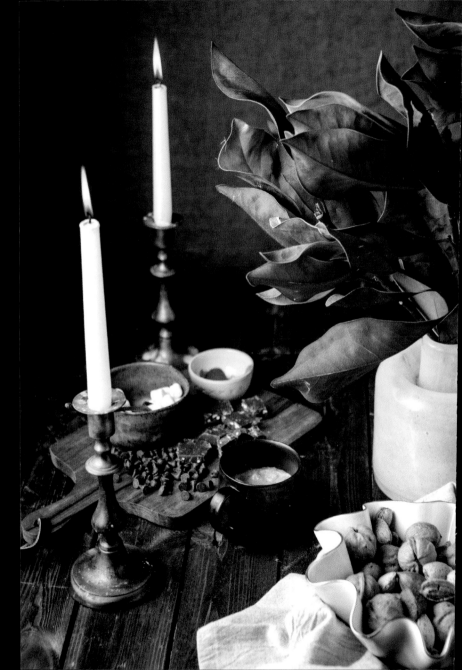

Promise

For to us a child is born, to us a son is
given, and the government will be on
his shoulders. And he will be called
Wonderful Counselor, Mighty God,
Everlasting Father, Prince of Peace.

ISAIAH 9:6

Jesus' birth is evidence that God keeps His promises. Since Old Testament times, God had been promising that He would send the Christ child, who would be known by these names: Wonderful Counselor, Mighty God, Everlasting Father, Prince of Peace. God fulfilled that promise in the birth of Jesus Christ.

Thumb through the Old Testament and you'll find that God has already fulfilled many of the promises He made to His people. God's timing is perfect, and in due time, He will fulfill all the promises He has made. Why is this important? Keeping

promises reveals that God is trustworthy. God keeps His promises for all of time, and you can trust that God will keep His promises to you.

This holiday season, one of the ways you can grow in your relationship with God is to let go and rely on His promises. Practically speaking, that means living in a way that demonstrates you trust God to keep His word. For instance, God has promised never to leave you or forsake you (Hebrews 13:5). He has promised to give you strength (Isaiah 41:10) and peace (John 14:27). He promises to care for every hair on your head. The Bible is packed full of promises. As you celebrate Advent, take some time to look through the Bible and find some of God's promises that speak to you. Remind yourself of God's promises throughout the day. Thank Him for His promises. Approach each day with confidence, knowing that God keeps His promises. Christmas is proof of it!

God, thank You for keeping Your promises. I praise You for sending Jesus—just as You said You would. I am counting on You to keep Your promises to me, and I thank You in advance because You are trustworthy.

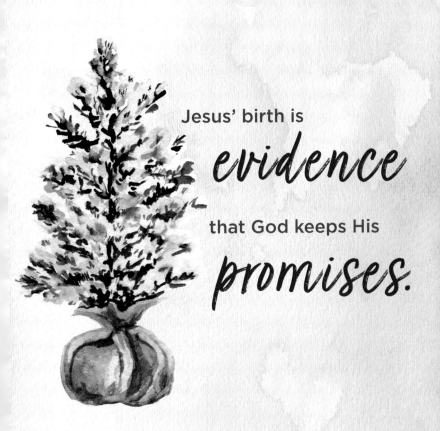

Jesus' birth is *evidence* that God keeps His *promises.*

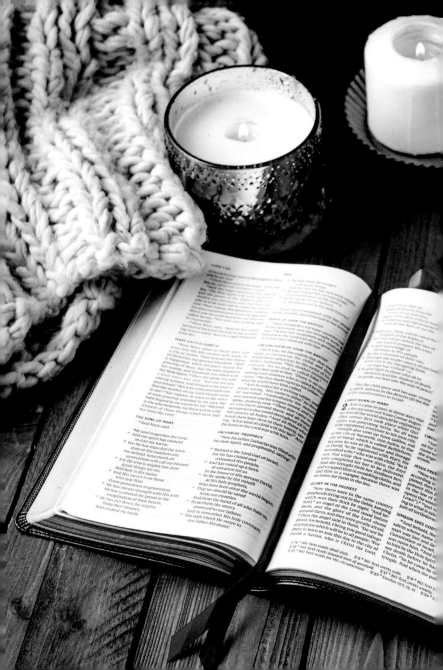

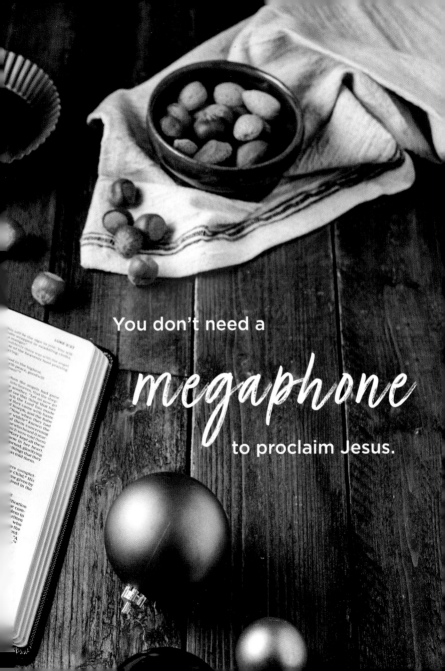

You don't need a

megaphone

to proclaim Jesus.

Proclaim

As it is written in Isaiah the prophet: "I will
send my messenger ahead of you, who
will prepare your way"—"a voice of one
calling in the wilderness, 'Prepare the way
for the Lord, make straight paths for him.'"

MARK 1:2–3

Imagine you're in for the night, already wearing your flannel pajamas and wrapping Christmas gifts. Wrapping paper, glitter, gift tags, tape, and shopping receipts cover the floor. The kitchen countertop is dusted in flour from baking cookies, and dishes are stacked in the sink. And there's a knock at the front door—old friends in town decided to drop by and say, "Merry Christmas." If you've ever had guests drop in unannounced, you might be thrilled to see them, but you probably wish you had known they were coming so you could prepare.

Jesus didn't arrive unannounced. John the Baptist was

sent ahead of Jesus so he could proclaim the good news of Jesus' coming (Mark 1:7), and he wasn't the only one to do so. Several of the Old Testament prophets announced that Jesus was coming—and it happened just as they had said.

Like John the Baptist and the Old Testament prophets, you can proclaim why Jesus' birth is good news. You don't need a theology degree or to know all the answers. One of the most powerful things you can do is live in a way that demonstrates why Jesus is important to you. That might happen in a conversation or simply in how you conduct yourself and go about your daily business. You don't need a megaphone to proclaim Jesus. Sometimes the most powerful proclamations about Jesus are quiet prayers and silent actions. Your faith may come up naturally over dinner or when talking about a movie. When you love Jesus, it's likely that love will be at the tip of your tongue. How you proclaim the good news will be up to you, and it doesn't need to sound like anyone else. Look for little opportunities to let your love pour out this Christmas season and proclaim what the birth of Jesus means for you.

Jesus, You are everything. Give me little glimmers of courage to open up and share about You. Use my life to proclaim Your glory.

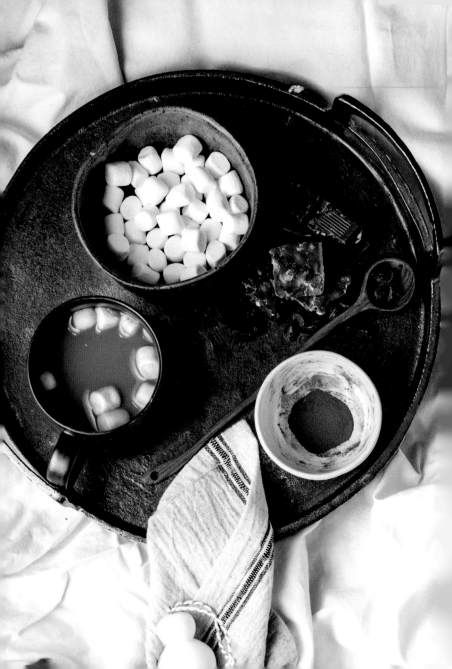

Prayerful

And pray in the Spirit on all occasions
with all kinds of prayers and requests.
With this in mind, be alert and always
keep on praying for all the Lord's people.

EPHESIANS 6:18

The holiday season brings a flurry of activity in a short time frame. By the end of December, it can seem like the month flew by in a rush. One of the ways you can slow down and savor the season is to practice a spiritual rhythm of prayer.

Maybe up until this point, you've approached prayer as a means of asking God for what you need, because the Bible teaches us to do this (Matthew 7:7–8), But you can expand your prayer life by embracing a prayerful spirit—that simply means talking to God throughout each day. Did you attend a holiday gathering you really enjoyed? Give thanks to God and tell Him

what you loved about it. Are you stressed about getting everything done before Christmas? Ask God to help you make the best use of your time. Did your eyes tear up when you watched your kids in their Christmas pageant? Tell God about it. Did the festival of lights take your breath away? Praise God for this gift.

As you embrace a prayerful spirit and communicate the details of your day to God, you'll grow in your relationship with Him and also experience the holiday season in a more meaningful way. You don't have to be in a formal posture of prayer to communicate with God. (Although sometimes you'll want to be.) God invites you to pray anywhere, anytime, for any reason—that's what it means to have a prayerful spirit.

Lord, help me devote myself to prayer. I want to enjoy a thriving prayer life. Help me develop a prayerful spirit.

Out of his fullness we have all received
grace in place of grace already given.

JOHN 1:16

One of the best parts of the holidays is watching the over-joyed reactions of little ones unwrapping the toys of their dreams. Maybe they're jumping up and down with joy or giving a quiet grin that expresses *this is exactly what I hoped for.*

It is such a delight to give gifts to those we love, especially when they're received with genuine thankfulness. Whether to a child, spouse, parent, or friend, we give out of the goodness of our hearts, not expecting a gift in return. We give because it's joyful.

Grace works similarly. Grace, in the Bible, means a gift freely given at zero cost to the recipient. God is the ultimate giver of grace, giving us His salvation through His Son, Jesus,

which in turn allows us to dwell forever with God in heaven. His grace allows us to know peace, forgiveness, and the sheer joy of communing with God.

As receivers of grace, we in turn get to extend it to others freely. The key word here? Freely. Where are you withholding grace today, either for yourself or someone in your life? What would it look like to lay down your anger or bitterness and let love lead instead? Giving grace is a never-ending process, and sometimes it's complicated. But just like that overjoyed child on Christmas morning who unwrapped his favorite toy, there may be someone out there whose eyes may brighten if they received some grace from you this season. Pray that God would help you give it freely.

God, thank You for the grace I have received in Jesus. He took the punishment I deserved. Help me give grace to others in the same measure You have given me.

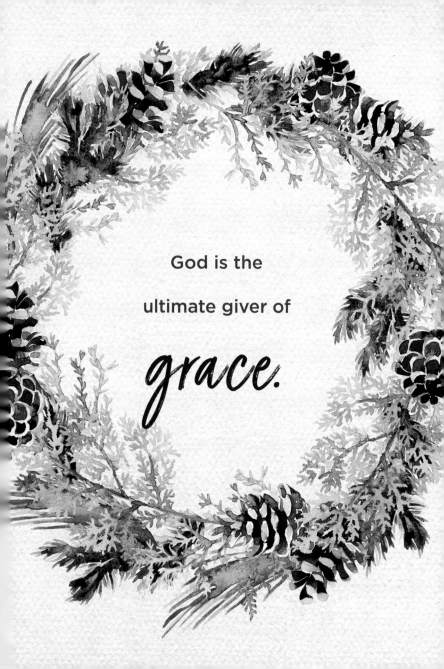

God is the

ultimate giver of

grace.

The Word became flesh and made
his dwelling among us. We have
seen his glory, the glory of the one
and only Son, who came from the
Father, full of grace and truth.

JOHN 1:14

During the holidays, people all over the globe celebrate the good news of the Christmas story. Some consider it a heartwarming tale or a really sweet metaphor. But is it true? Did it really happen? A virgin gave birth to a Savior in a stable, and that little boy grew up to be the most life-changing figure in all of history? It's a wild story!

There are so many wonderful books and teachers that can help you work through your doubts or questions about whether this is just a good story or it's really true. If you are approaching

this Christmas season and are wondering whether all of this is true, don't push those questions down. Ask them. Jesus Himself invited skeptics to come and ask Him questions. People from all different backgrounds found belief because they came and met the real Jesus.

As you're praying this Christmas, don't be afraid to ask more of Jesus. Read the Bible, where you can get to know Him best, and dig in! Jesus can handle your questions, He can handle your doubts, and He promises you love and freedom.

Jesus, thank You for being full of grace and truth. Help me have courage and discipline to explore my doubts, and the wisdom to better understand Your teaching.

Rejoice greatly, Daughter Zion!
Shout, Daughter Jerusalem! See,
your king comes to you, righteous
and victorious, lowly and riding on a
donkey, on a colt, the foal of a donkey.

ZECHARIAH 9:9

Typically, the birth of a king takes place in a palace surrounded by a large staff. A royal birth announcement is followed by important visitors and formal procedures. But Jesus wasn't a typical king. He was born in a stable with just Mary and Joseph. Later in Jesus' life, He would ride into Jerusalem on a donkey, which was lacking in the pomp and circumstance one might expect of royalty.

Jesus' rule is different from any other king who has ever

been on the throne. Jesus isn't simply a king. He is the King of kings and Lord of lords (1 Timothy 6:15). Jesus holds all power, and His rule covers every millimeter of the earth. Yet Jesus is the humblest of all kings. Jesus' humble characteristics don't stem from a lack of power. His humility is rooted in love.

This Christmas take comfort in knowing that Jesus is a humble King. His rule isn't motivated by politics; it's motivated by love. And His kingdom will have no end (Isaiah 9:7).

Jesus, I am in awe of Your power and challenged by Your humility. Thank You for being a humble King. I praise You for being a King who is motivated by love.

Jesus isn't simply a king. He is the

Kingofkings

and Lord of lords.

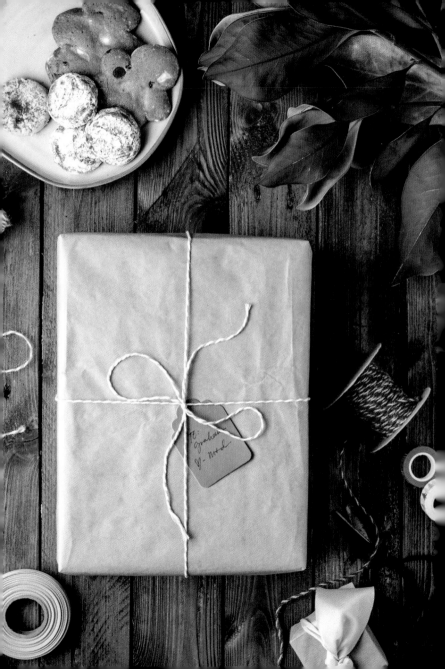

Anticipation

Now to him who is able to do
immeasurably more than all we ask or
imagine, according to his power that is
at work within us, to him be glory in the
church and in Christ Jesus throughout all
generations, for ever and ever! Amen.

EPHESIANS 3:20–21

When you're a child waiting for Christmas, the days move by at a turtle's pace. By the time the big day arrives, the Christmas Eve worship service is filled with wide-eyed and wiggly kids bouncing on church pews as they daydream about opening gifts. Children have a lot to teach us about waiting with anticipation. There's a big difference between waiting with anticipation and simply waiting. Being wide-eyed and wiggly is a lot more fun.

As a believer, you have good reason to approach each

day with anticipation. God delights in blessing you. In fact, God saved you oo "he might show the incomparable riches of his grace, expressed in his kindness to us in Christ Jesus" (Ephesians 2:7). Simply put, God enjoys being kind and lavishing you with His grace. As a follower of Jesus Christ, your best days are always ahead of you (Revelation 21:4).

As Christmas approaches, express your excitement about what's around the corner—whatever that looks like for you. Waiting turns into anticipation when you believe good things are on the horizon. King David said, "I remain confident of this: I will see the goodness of the Lord in the land of the living" (Psalm 27:13). So call a friend, sing about it, or maybe even take a cue from the toddler in the pew beside you and let out a wiggle! Jesus has come, and He will come again.

God, it's hard for me to wrap my mind around Your grace and kindness. Help me live with anticipation of good things ahead. Teach me live with hope and expectation because You are a kind and good God.

Savior

This is a trustworthy saying that
deserves full acceptance. That is
why we labor and strive, because we
have put our hope in the living God,
who is the Savior of all people, and
especially of those who believe.

1 TIMOTHY 4:9-10

The Christmas story reaches its high point with the birth
of the Savior—Jesus Christ, the Son of God. Jesus came to
the world as Savior because mankind needed to be saved from
sin. Because of Christ's birth, death, and resurrection, all
people have the opportunity to trust Christ as Savior, receive
God's forgiveness, and become a child of God (John 1:12). But
following Jesus isn't only about eternal life—it's also about liv-
ing in God's fullness in the here and now.

The Gospel of John tells the stories that took place during

Jesus' time here on earth. Near the end of the book, John gave his reason for writing down the stories about Jesus. He said, "But these are written that you may believe that Jesus is the Messiah, the Son of God, and that by believing you may have life in his name" (John 20:31).

The phrase "life in his name" is key to understanding the fullness of the Christmas story. Knowing Jesus means you will spend eternity with Him in heaven—thank God for that! But if you are a follower of Jesus Christ, "life in his name" starts now. That means that as you approach each day, you can rely on Jesus to meet your needs. It means having a vibrant relationship with your Savior today, tomorrow, and always. What a gift! What a Savior!

Jesus, I praise You for being my Savior. I want to experience life in Your name in the here and now. Help me have a vibrant relationship with You. Jesus, You are everything.

Following
Jesus
is about living in God's
fullness
in the here and now.

God

delights

in blessing you.

Notes

1. *HCSB Study Bible: Holman Christian Standard Bible: God's Word for Life* (Nashville: Holman Bible Publishers, 2009), 1734.
2. *HCSB Study Bible*, 1734.
3. *Holman Bible Dictionary* (Nashville: Holman Bible Publishers, 1991), 660–61.